D0505188

MEMENTOS

AS MEMORY MAY BE A PARADISE
FROM WHICH WE CANNOT BE DRIVEN,
IT MAY ALSO BE A HELL FROM WHICH
WE CANNOT ESCAPE.

John Lancaster Spalding

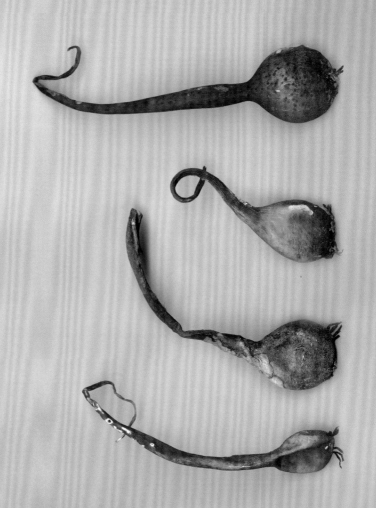

PHOTOGRAPHS BY

JENNIFER KEATS

SUSAN COOLEN

HEIDI BEACH

ANGELA WATTERS

MARY FARMILANT

CHRISTINE DiTHOMAS

HEATHER JOHNSON

MEMENTOS

Columbia
COLLEGE CHICAGO

JENNIFER KEATS

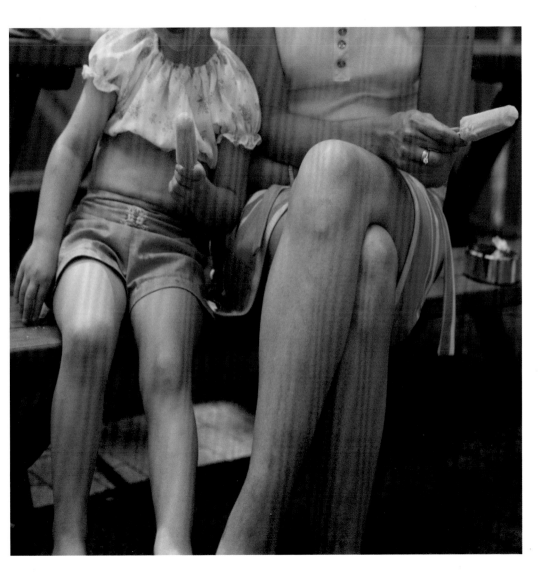

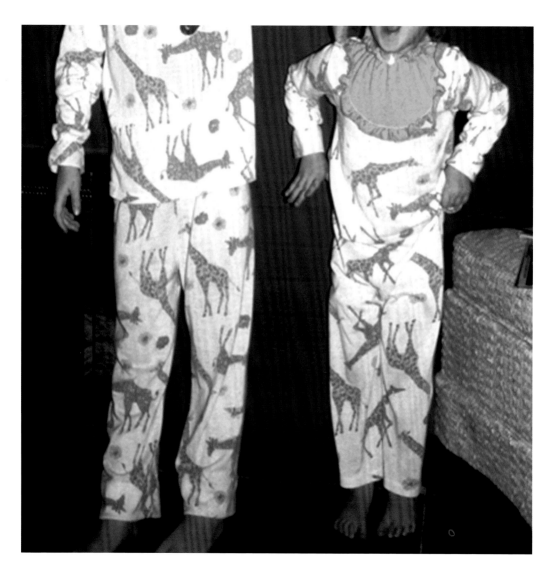

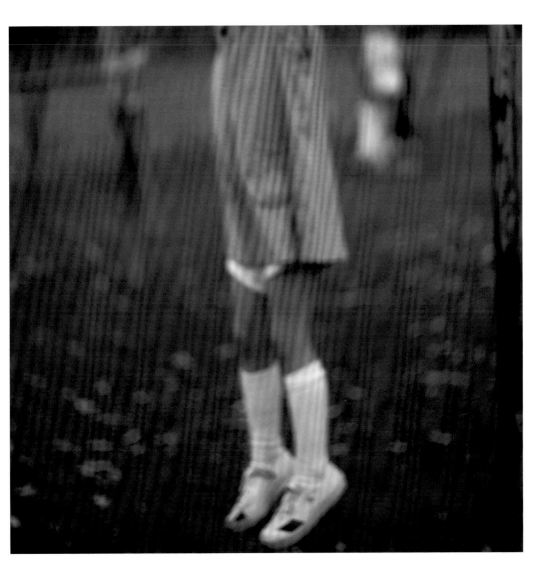

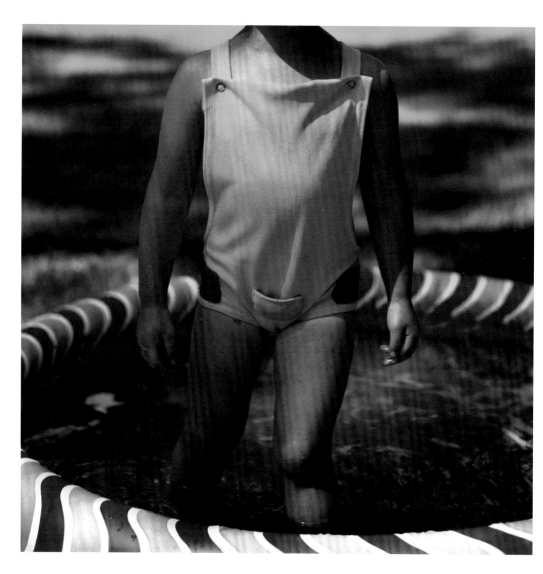

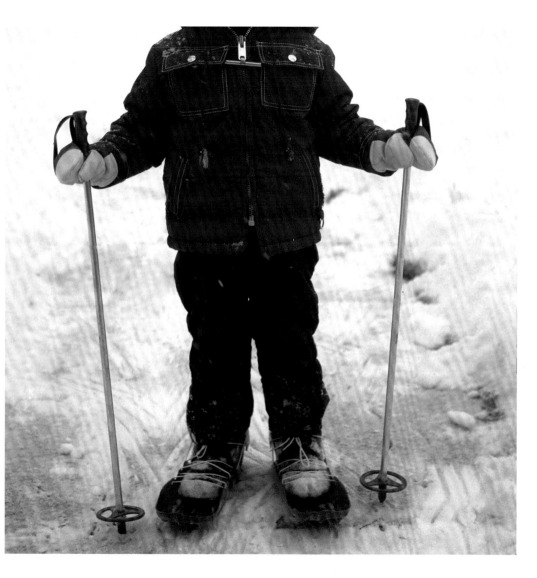

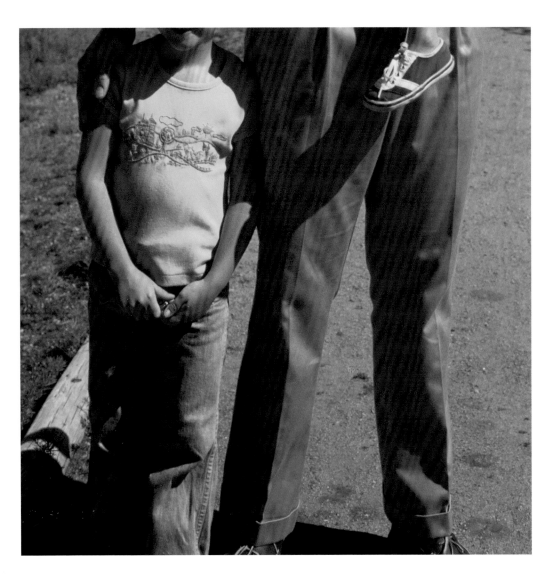

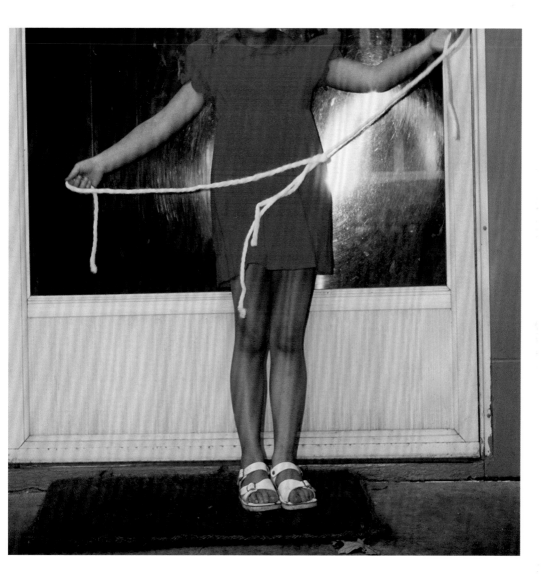

SUSAN COOLEN

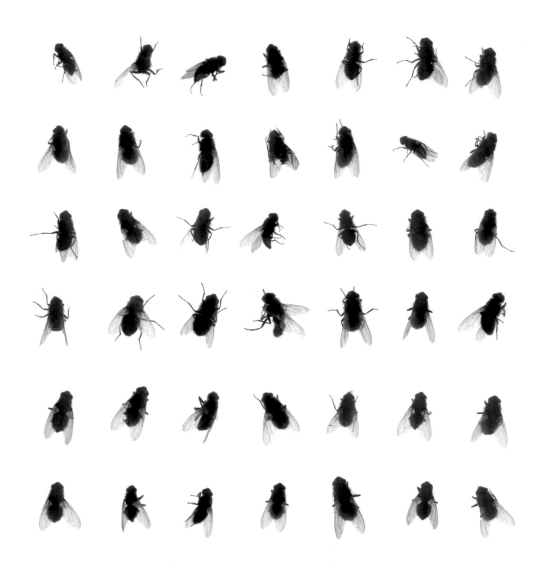

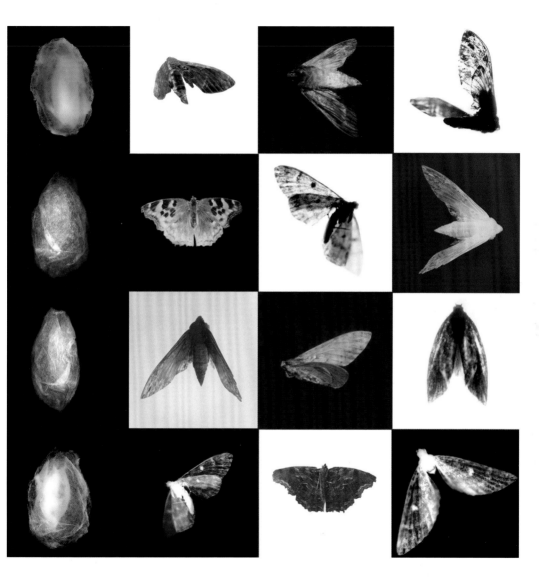

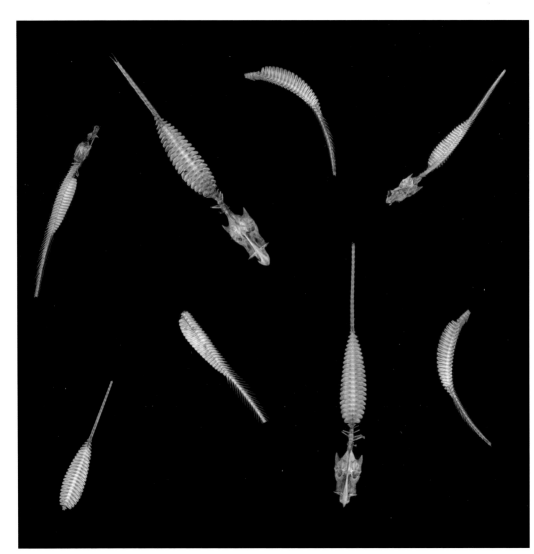

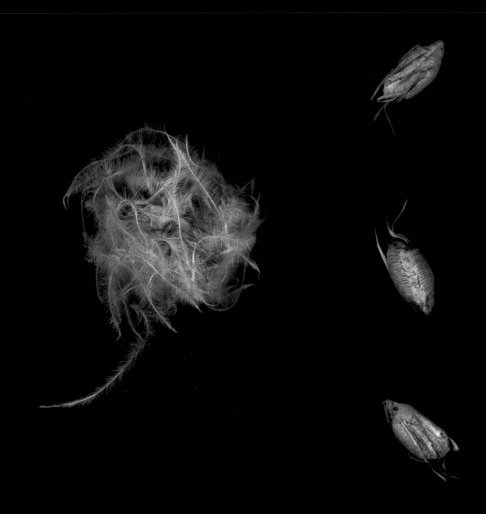

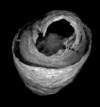 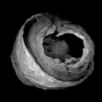 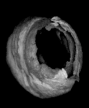

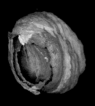 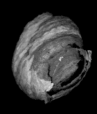 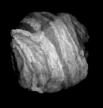

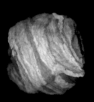 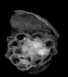

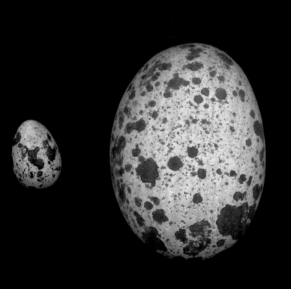

HEIDI BEACH

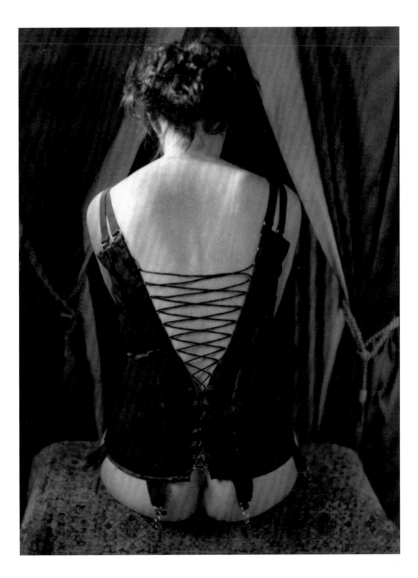

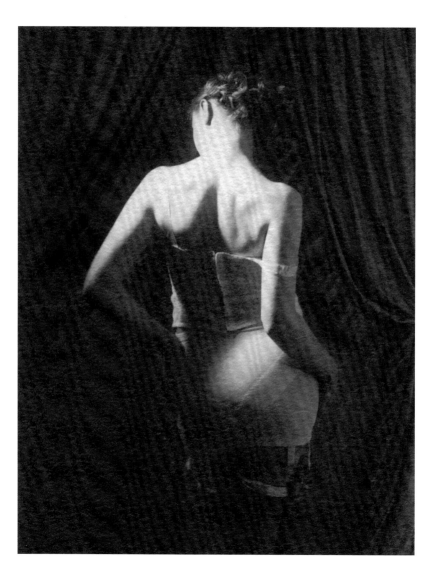

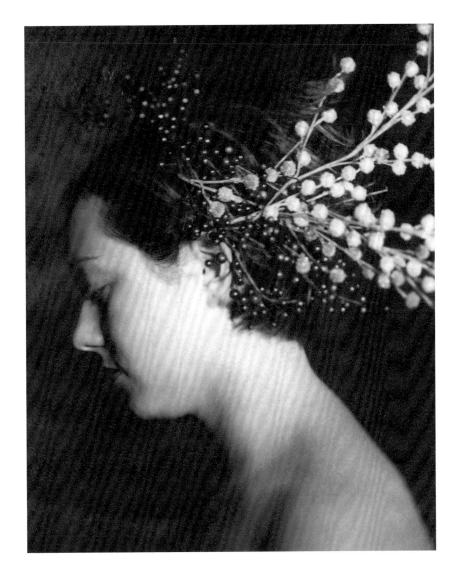

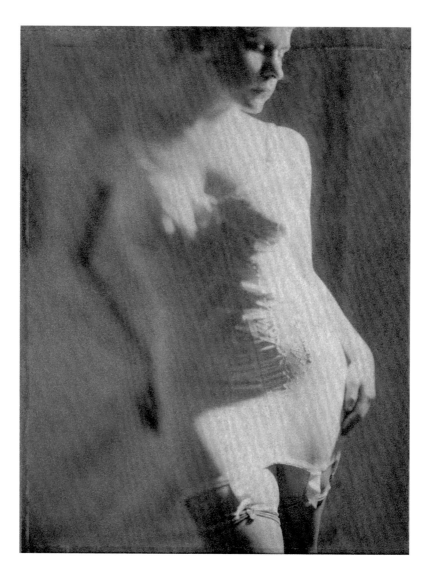

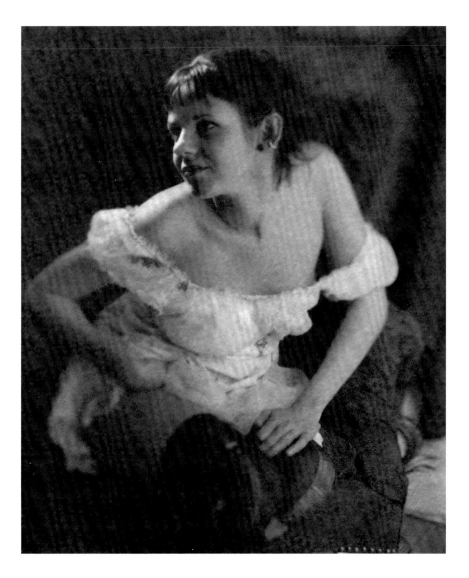

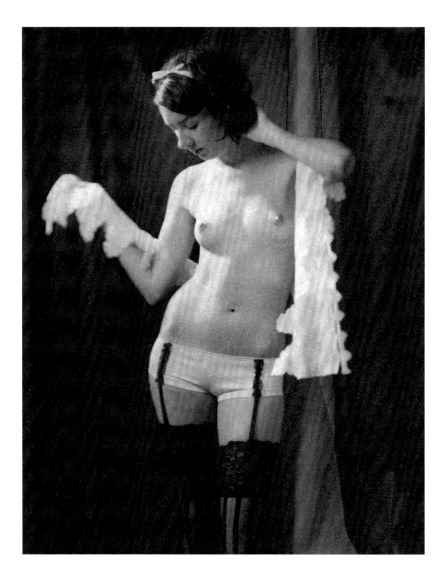

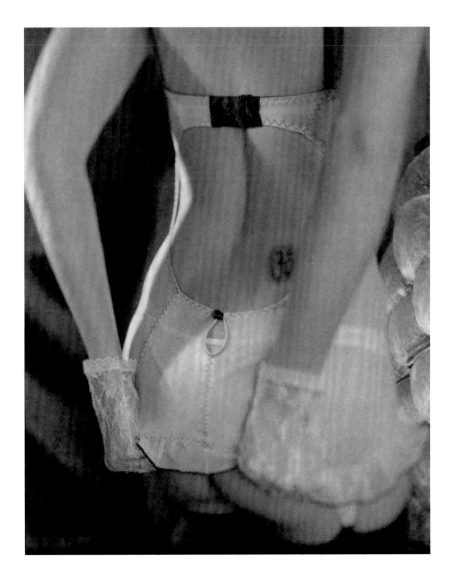

ANGELA WATTERS

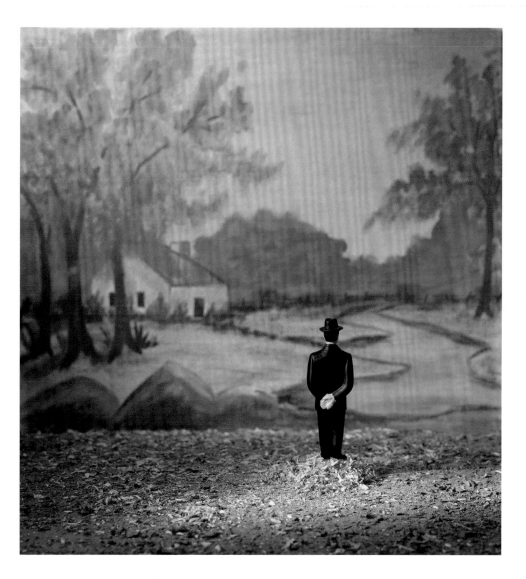

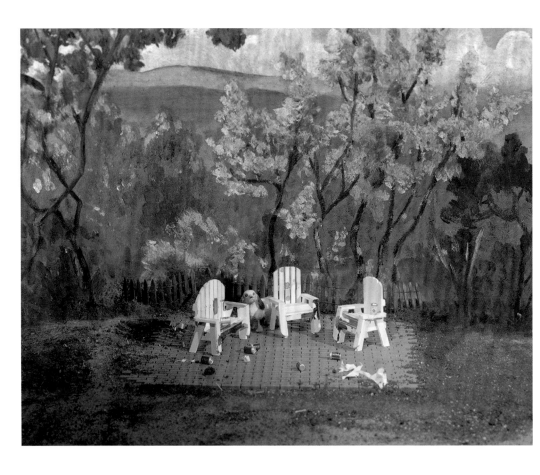

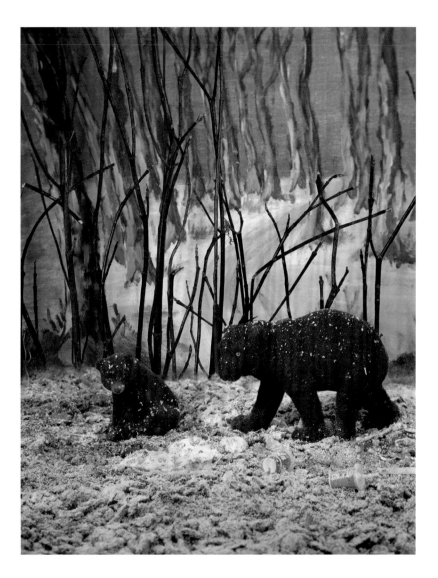

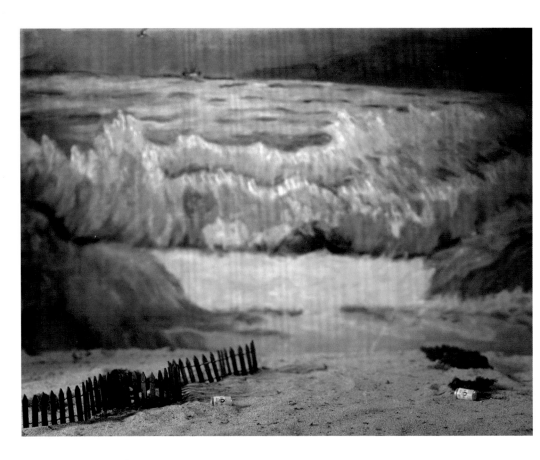

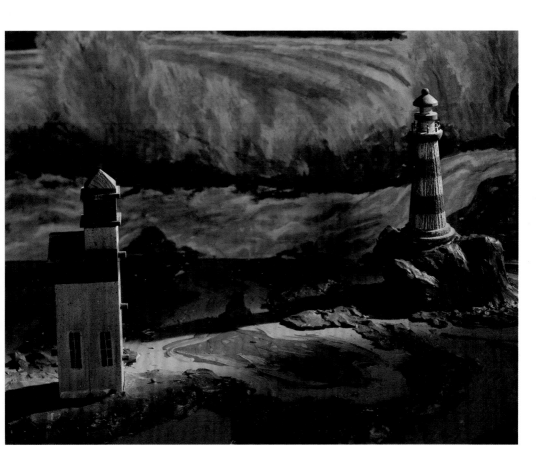

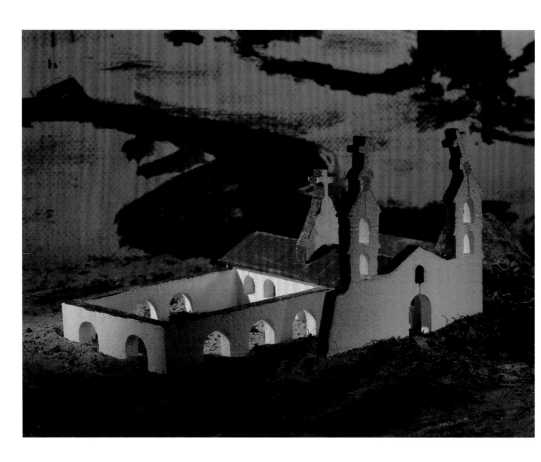

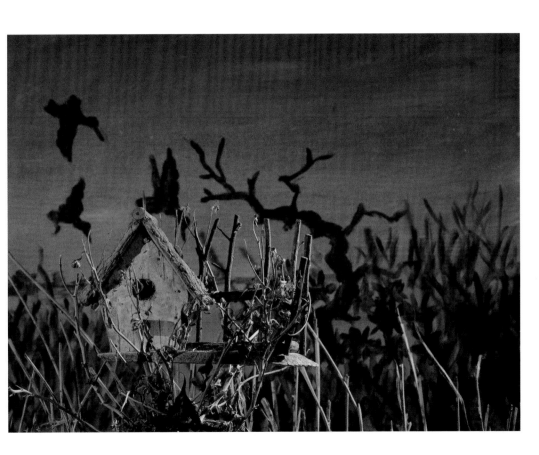

MARY FARMILANT

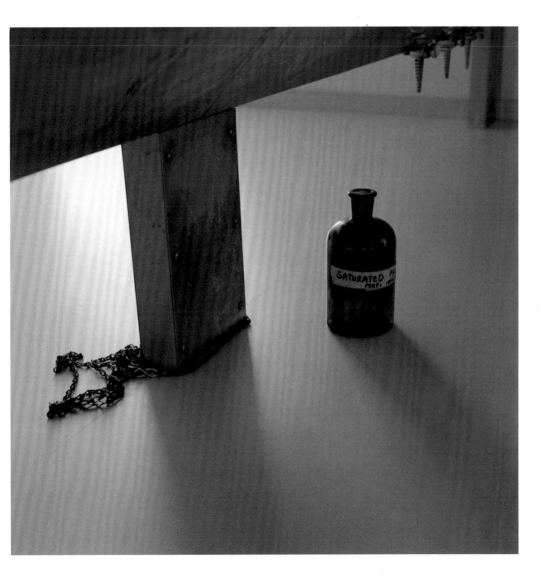

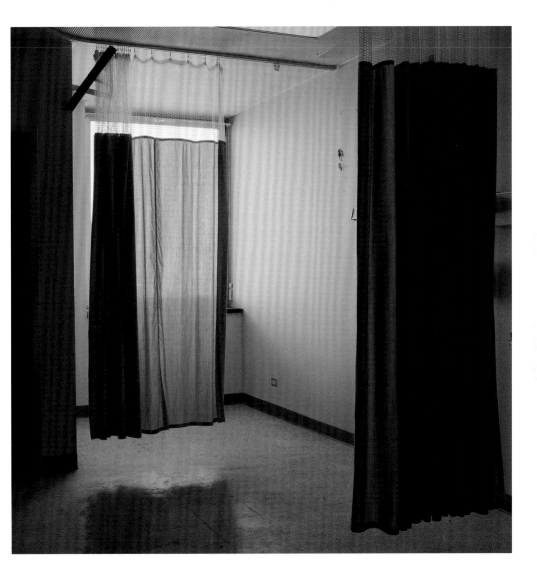

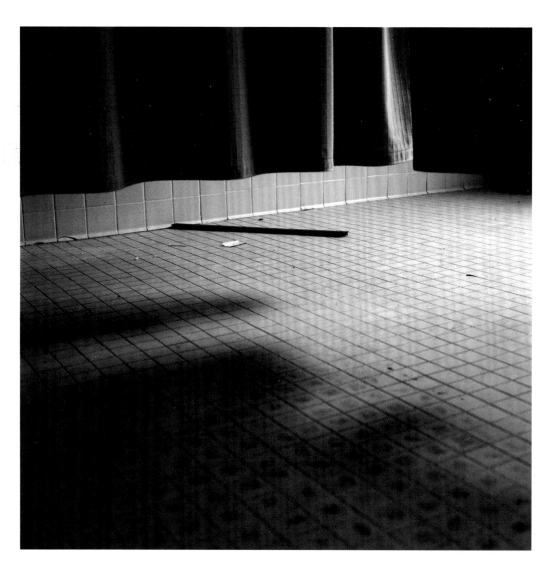

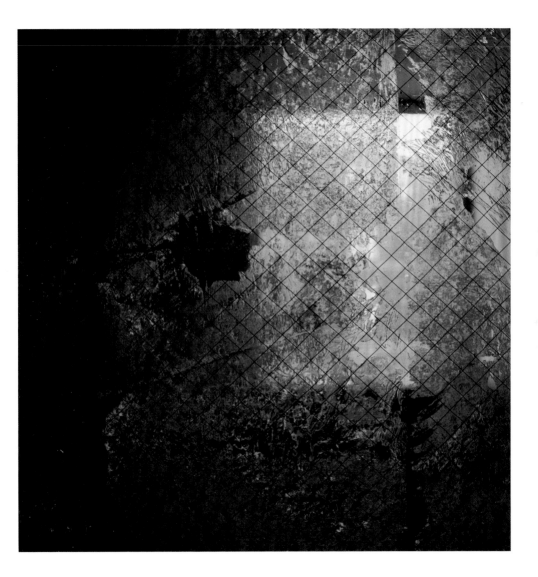

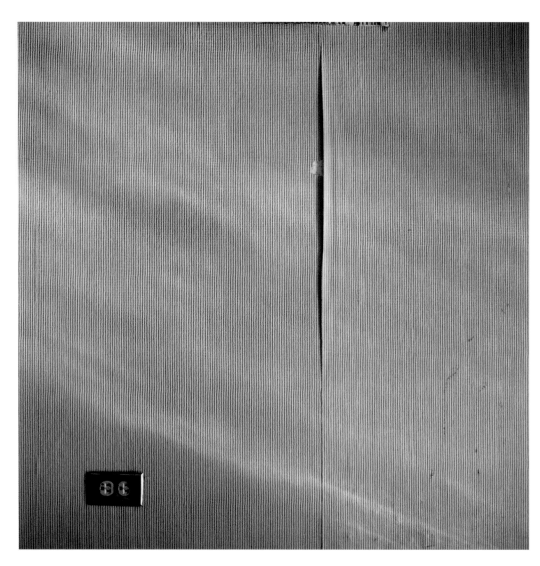

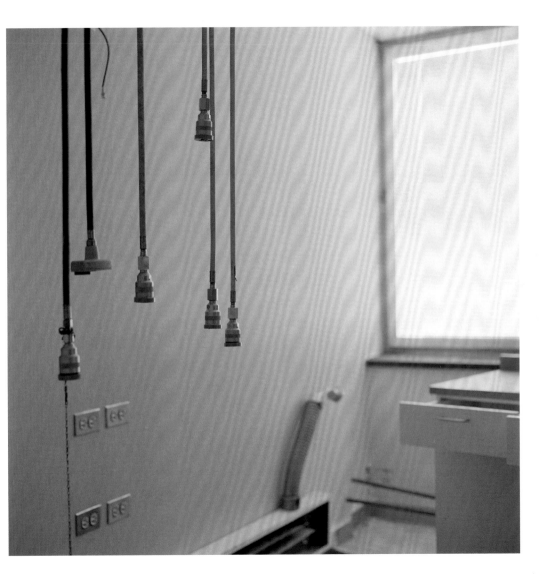

CHRISTINE DiTHOMAS

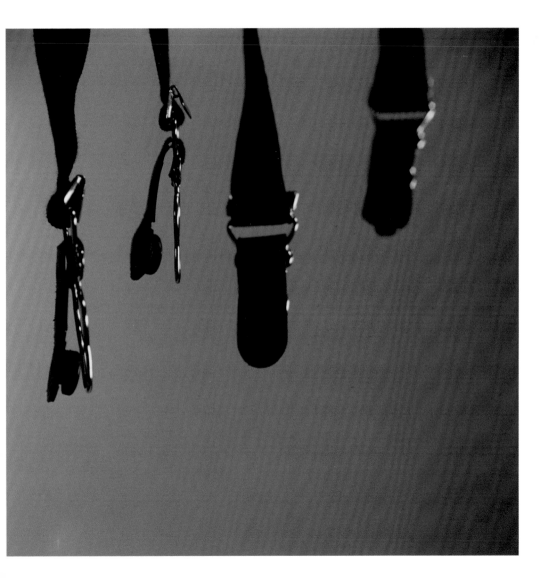

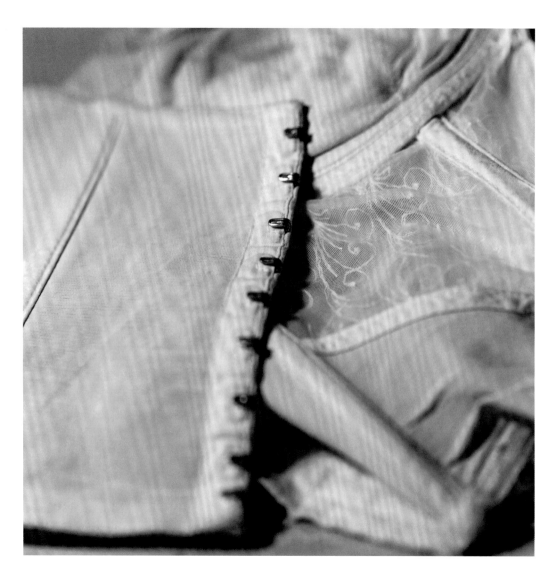

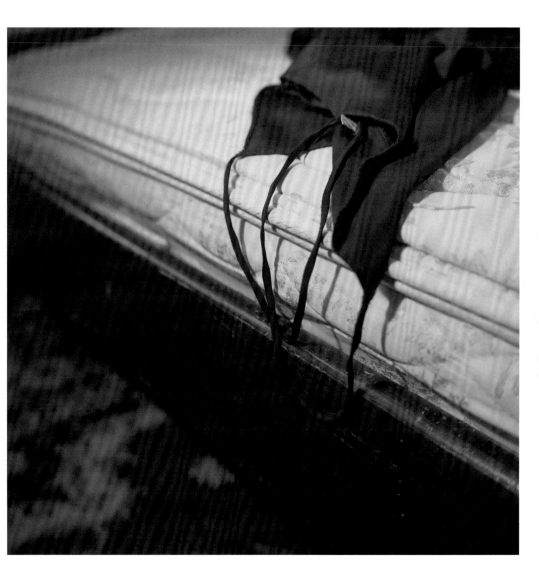

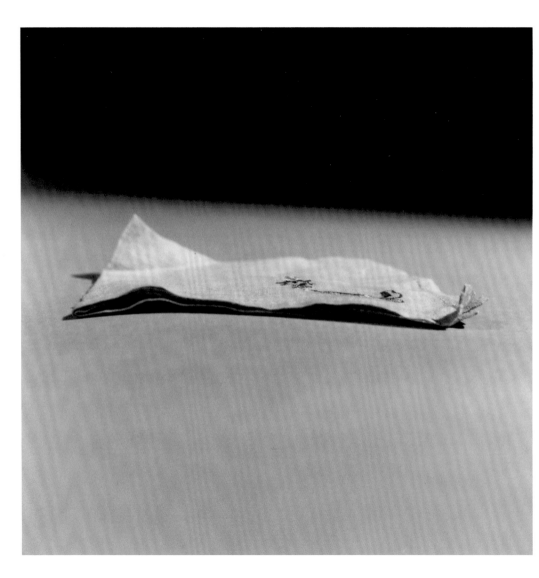

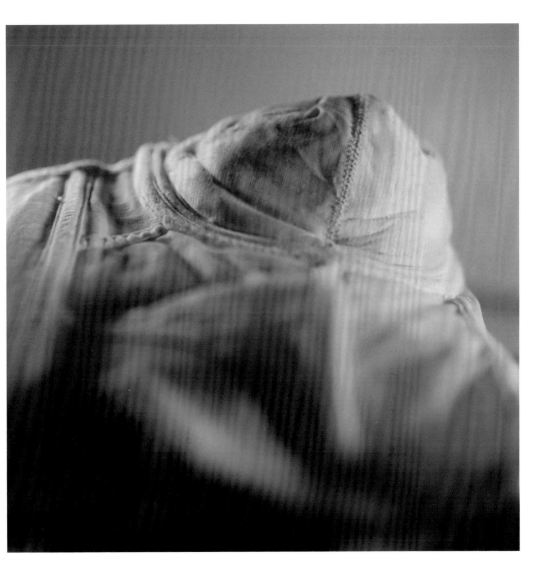

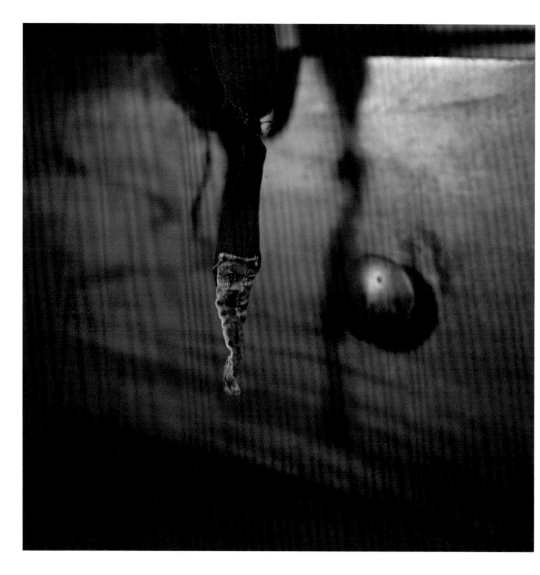

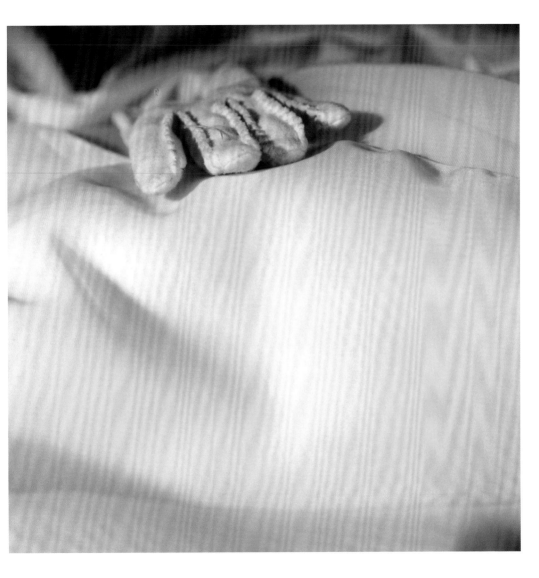

HEATHER JOHNSON

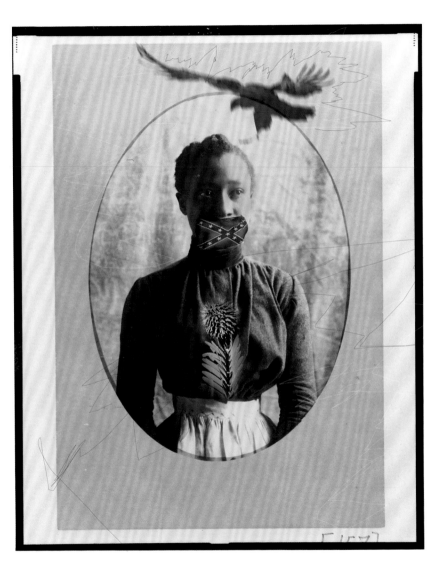

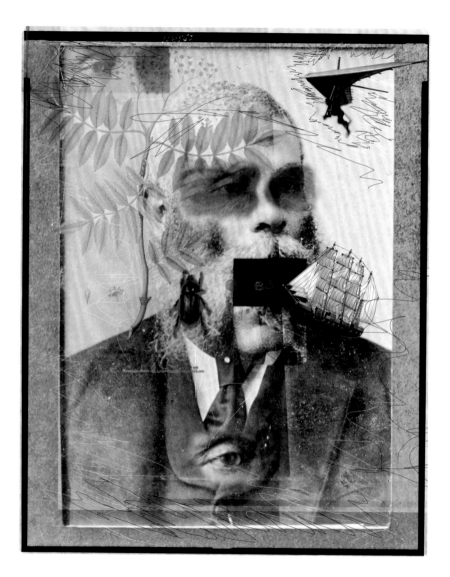

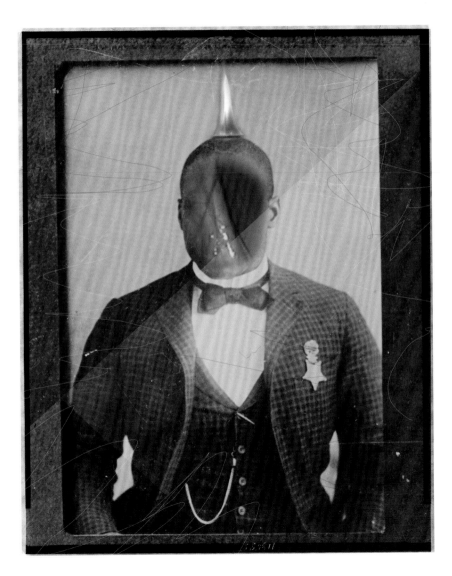

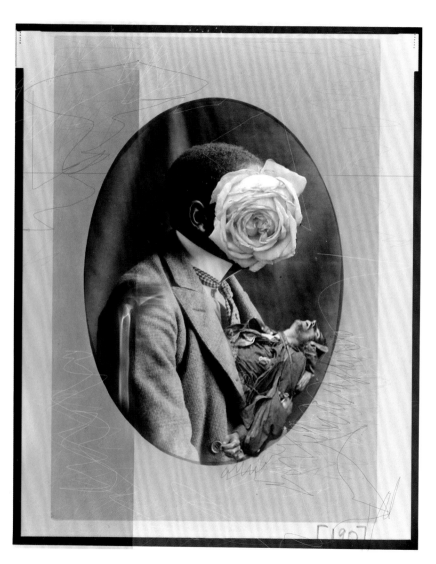

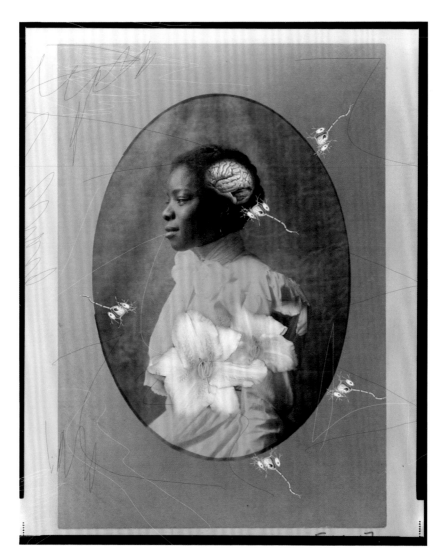

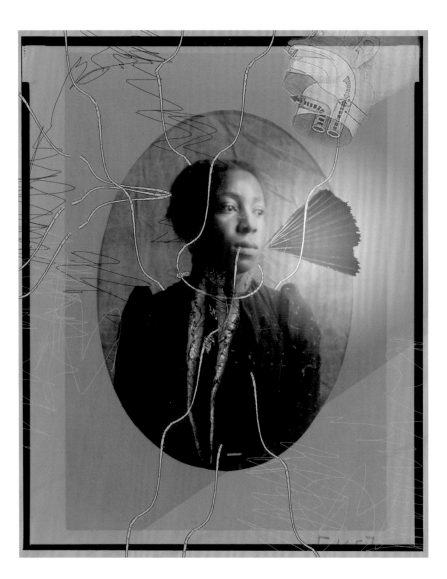

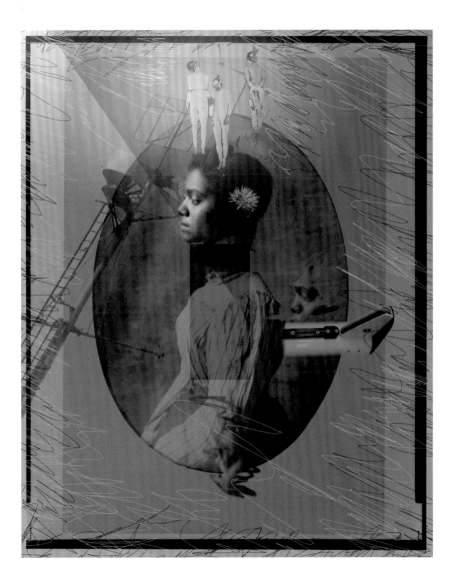

HEIDI BEACH (b. 1973, Waukegan, Ill.) received a BA in photography from Columbia College Chicago, where she was awarded the Albert P. Weisman Memorial Scholarship. She has exhibited her work in Chicago and in Florida, including at the Columbia College Student Honors Show, the Hokin Gallery, Vespine Gallery, and Echo Gallery. Her photographs have been published in *CMYK, Venus*, and on the *PDN* student webgallery.

My pictures reference the erotic photographs of women first seen in the 1800s. At that time, those sensual images were considered pornographic by most, but by today's standards they are viewed as stylized fine art studies of the female form. I am interested in the way the 19th century photographs subtly portrayed female sexuality, in contrast to modern photographs in which nothing remains secret or forbidden. My photographs allow the viewer just a glimpse into the female models' domain—capturing their vulnerability and their strength, and the emotions that occur when they think no one else is looking. I re-create the essence of the earlier burlesque photographs by selecting particular furniture and garments, and rich textures in the drapery and lace. To further this effect, I print the images using the 19th century albumen printing process.

4″ x 5″ albumen prints on art paper www.heidibeach.com

SUSAN COOLEN (b. 1955, Halifax, Canada) is a Montréal-based artist. She received a BDes in communication design from the Nova Scotia College of Art and Design, a BFA in photography from Concordia University in Montréal, and an MFA in photography from Columbia College Chicago. Her exhibitions include a two-person show at Metrònom in Barcelona, Spain; the Canadian Museum of Contemporary Photography and National Gallery of Canada's *On Tour* program; and *Encontros con la Image* in Tenerife, Canary Islands, Spain; as well as shows in Pittsburgh, Toronto, Vancouver, Kitchener, and Montréal. Publications include *Photo Vision: Big Crunch No. 30, Terre Océane, Scrivener Creative Review, Sphere,* and *Québec Science* magazine.

Le Spectacle de la Nature: A Collector's Compendium and *Celestial Travelers* Originating out of a childhood ritual of scavenging the shoreline of a small coastal village for washed-up treasures, my photographic practice revolves around the constant activity of collecting specimens (which I often mummify), found objects, and the detritus of daily life. My work is informed by my interest in natural history, the museum, astronomy, science, and storytelling.

12" x 14" to 24" x 36" archival digital inkjet prints susancoolen@yahoo.com

CHRISTINE DiTHOMAS (b. 1960, New Castle, Pa.) holds a BA in liberal arts from Duquesne University and an MFA in photography from Columbia College Chicago, where she received the Albert P. Weisman Memorial Scholarship and the Fashion Columbia Photography Award. Her photographs have been exhibited at Zolla/Lieberman Gallery, Hyde Park Art Center, Schopf Gallery, A.R.C. Gallery, and Crown Gallery, among others in Chicago, and at the Miami Art Expo, the Texas National, and the Beijing Natural Cultural Center in China. Publications include *Mouth-to-Mouth* magazine, *Concentrics, Muse* magazine, and the British journal *Performance Research*.

Imperfect Contrition (2001) These photographs of vintage women's garments and accouterments are part of a 16-piece image and text series that alludes to a concept within the Roman Catholic rite of confession. I am interested in the mystery and power of these objects—some discarded, others carefully preserved—which hint at rituals, either private and personal or specifically religious.

16" x 16" to 27" x 27" chromogenic prints www.christinedithomas.com

MARY FARMILANT (b. 1954, Loraine, Ohio), a Chicago-based artist, earned both a BA with honors and an MFA in photography from Columbia College Chicago, where she was awarded the Follett Graduate Fellowship, the Graduate Opportunity Award, the Getz Graduate Award, the Albert P. Weisman Memorial Scholarship, and the Stuart and Iris Baum Project Completion Grant. She received first prize in the 2005 Golden Light Awards Print Competition. Her work has been exhibited nationally. Farmilant teaches part-time at Columbia College Chicago and Gallery 37 Center for the Arts.

Columbus Hospital Series Many hospitals are "dying" of an insidious disease they cannot cure: a "profit plague" that devastates medical institutions all over the country. My work records the deterioration of an abandoned institutional space and the evidence of human presence that remains behind. Columbus Hospital in Chicago, where I worked for 14 years as a nurse, was recently decommissioned and slated for demolition; million-dollar condos and townhouses will be built in its place. I want these photographs to invoke the hospital's past while recording the space at its moment of transition. Although these images are of one hospital, they serve to describe the current crisis of health care in the United States.

30" x 30" archival digital prints mfarmilant@aol.com

HEATHER L. JOHNSON (b. 1974, Honolulu, Hawaii) received a BA in photography from Columbia College Chicago. Her photographs have been exhibited at Muse Gallery in Prescott, Arizona, Vespine Gallery in Chicago, and the Washington Gallery of Photography in Bethesda, Maryland, among others, and have been published in *Photographer's Forum*. Johnson received a 2005 Lucie Award for the *Reparations* series.

Reparations focuses on the emotionally damaging effects of slavery on black people in America. By digitally manipulating classical portraiture of middle-class African Americans from the early 20th century, and using cultural iconography such as plants, animals, and other references to the natural environment, I am able to heighten the drama and place the viewer in a distinct time and place. In altering the portraits, I reveal the strength of African Americans, while emphasizing the destructive nature of slavery.

8" x 10" to 12" x 12" silver gelatin on aluminum hjohnson51@yahoo.com

JENNIFER KEATS (b. 1971, Evanston, Ill.) received a BA in graphic design from Michigan State University and an MFA in photography from Columbia College Chicago. Her work has been exhibited at the Three Arts Club, Vespine Gallery, and 11th Street Gallery. Keats teaches digital imaging part-time at Columbia College and the Evanston Art Center, and designs and executes websites for artists and small businesses in the Chicago area.

This project arose from my interest in the relationship between family photographs and memory. When looking through my own family photographs, specifically the images that my father had taken of my little sister and me in the years before he died, I noticed a strange phenomenon. Sadly, I could no longer remember the man who had taken the photographs, but I could remember events or even objects from the time period. By removing the identities of the children in these photographs through cropping, I hope to produce for the viewer those same disjointed feelings of desire and mourning.

30" x 30" archival digital prints www.jenniferkeats.com

ANGELA WATTERS (b. 1975, Houston, Tex.) holds a BFA in photography from New York University's Tisch School of the Arts. She is an MFA candidate in photography at Columbia College Chicago. Watters was a Union League Club Civic and Arts Foundation finalist and received the Club Choice Award.

I create tableaux that address the relationship between a traditional, idealized depiction and a more realistic, contemporary understanding of the American landscape. Using the landscape paintings of my great-aunt Wilma Watters Johnson, a prolific self-taught artist, as inspiration and as backgrounds to my photographs, I add set-up scenes comprising miniatures, craft materials, and tchotchkes. Through this juxtaposition I am able to reflect and comment on the romantic nature of her paintings, and also have an otherwise impossible conversation with my late great-aunt on the subject of art and nature.

20" x 24" archival digital prints angela_watters@yahoo.com

MEMENTOS is no. 4 in the *6x6 Series* of photography books.

The *6x6 Series* is published by
the Photography Department of Columbia College Chicago
at 600 South Michigan Avenue, Chicago, Illinois 60605.
www.colum.edu

Series Coordinators: Tammy Mercure (tmercure@colum.edu)
 Bob Thall (bthall@colum.edu)

Design by Colleen Plumb (www.colleenplumb.com)

Printed in Iceland by Oddi Printing, Ltd.

We would like to thank the artists and Thorsteinn (Steini) Torfason at Oddi.

© 2006 Photography Department, Columbia College Chicago.
Photographs are copyright of the individual artists. All rights reserved. No part of this
publication may be reproduced, stored in a retrieval system or transmitted in any form
or by any means, electronic, mechanical, photocopying, recording or otherwise, without the
prior permission of the Photography Department, Columbia College Chicago, or the artists.

ISBN 0-929911-16-4

Cover photograph: Jennifer Keats
Frontispiece: Susan Coolen